Nautical Highways

Ferries of the San Juan Islands

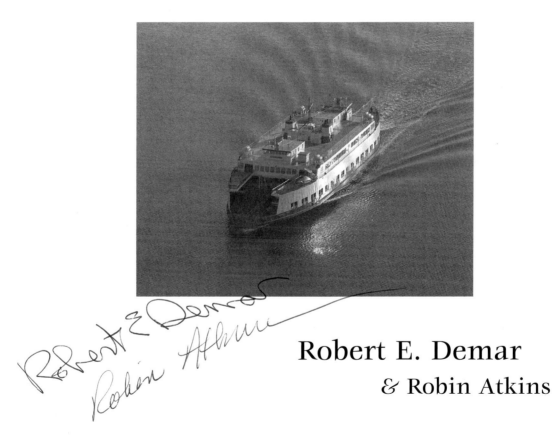

Robert E. Demar

& Robin Atkins

Nautical Highways
Ferries of the San Juan Islands

ISBN: 0-9705538-3-8

Tiger Press
& Rain Barrel Productions

837 Miller Road
Friday Harbor, WA 98250
email: tigerpress@interisland.net

Photographs: Front cover - the *Evergreen* State docked at Orcas Island as seen through the *Illahee*'s car deck porthole. Back cover - the *Evergreen State* docked at Friday Harbor; the *Hiyu* and Mt. Baker.

Dedication

We dedicate this book to all the Washington State Ferry (WSF) captains and crews who have served in the San Juan Islands. We tip our hats, as well, to the worthy vessels, especially the retired *Hiyu* and the venerable *Illahee* and *Nisqually*. We commend the state of Washington for its concern for island communities in the Puget Sound region, when in 1951 it bought existing privately-owned ferries and terminals, and began an expansion program. Washington State eventually added WSF to its Highway Department, giving us the title for our book, "Nautical Highways." The incomparable beauty and charm of the San Juan Islands make these highways some of the most frequently traveled in the state.

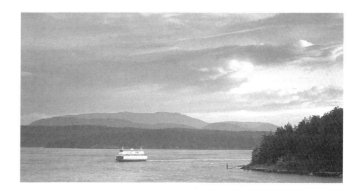

Acknowledgments

Without help from many individuals in the WSF system, this book would not be possible. We thank them all, but especially the captains who took us into their pilothouses and explained the running of their ships. We thank Captain Jack Hamstra for his cheerful support, Dave Black for the answers to numerous questions, Chief Mate Greg Griffith for reviewing and advising us about many of the photographs, and Captain Fred Engstrom for his help with locations.

Thanks also to skippers Rick Waldron, Craig Jensen, and Louie Eyman for taking Robert out where he could photograph ferry boats from a different perspective. Thanks to the Coupeville Arts Center on Whidbey Island for offering quality photography workshops; we met there in 1997. And finally we thank each other for bringing our different skills and a true spirit of team work to the fulfillment of this project started by Robert a decade ago.

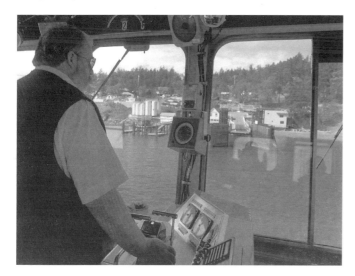

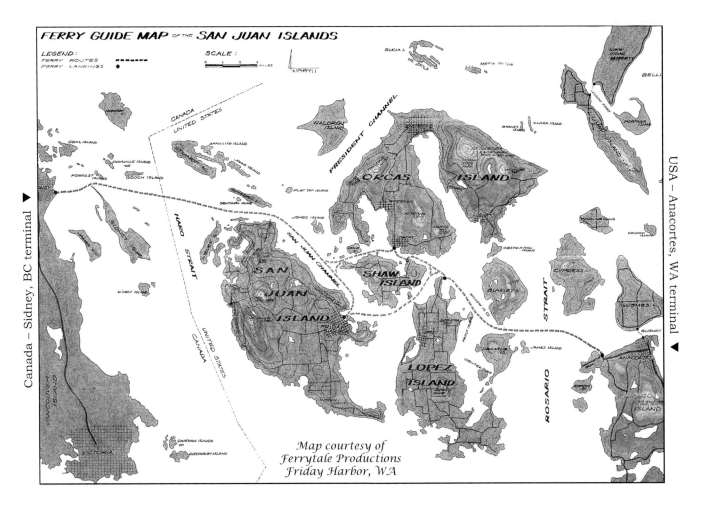

map of San Juan Islands showing ferry routes and terminals
international route - Anacortes, WA to Sidney, BC - round trip 80 miles
interisland route - San Juan, Orcas, Lopez, and Shaw Islands

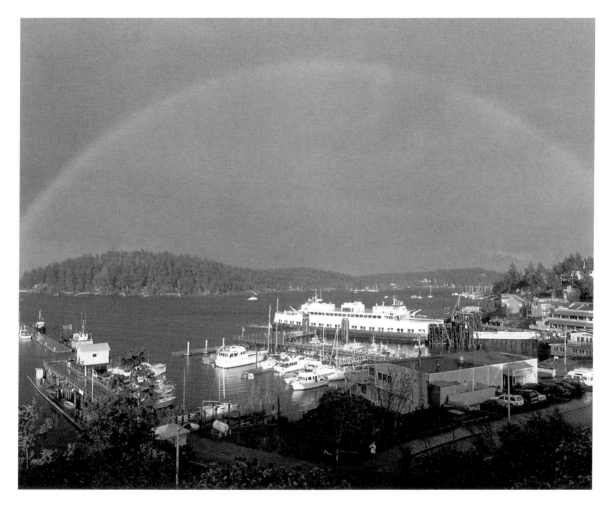

rainbow seen from the center of San Juan Island
grab camera gear and follow the arches over hill and valley to town
brilliant showcase for the *Evergreen State*

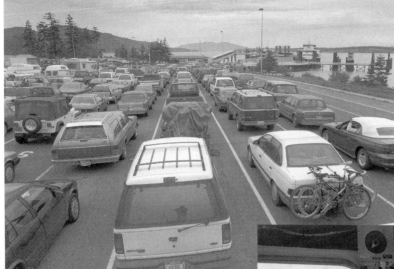

cars waiting
ferry arriving
opposite views in Anacortes

Captain Dave Alger
backing down the *Nisqually*
easing toward the wing walls

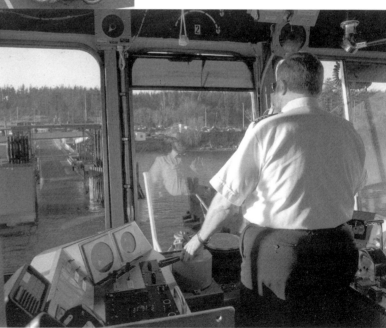

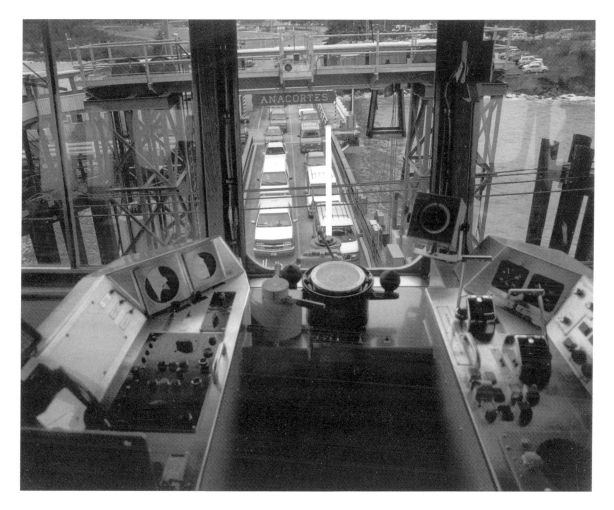

Nisqually - empty pilothouse - cars loading in Anacortes
Captain on his way to duplicate control systems in the outbound pilothouse
blast of horn coming soon - signaling departure

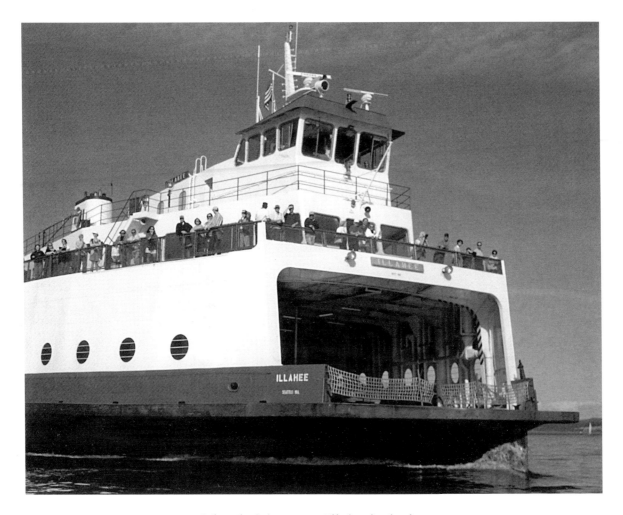

island visitors on *Illahee*'s decks
360° view of Rosario Straits - warm September day
aromas - salt water, sun baked Madrona leaves, sweet ripe berries

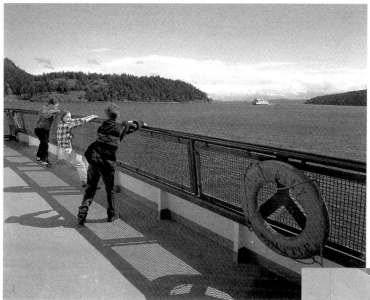

kids playing
hanging on the *Nisqually*'s deck rails
carefree, joyous, zestful

running not permitted
irresistible
have deck, will run

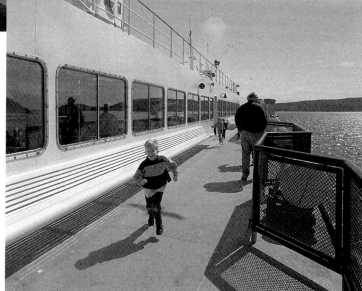

Illahee pilothouse
view from Rick's boat
passengers and flag waving

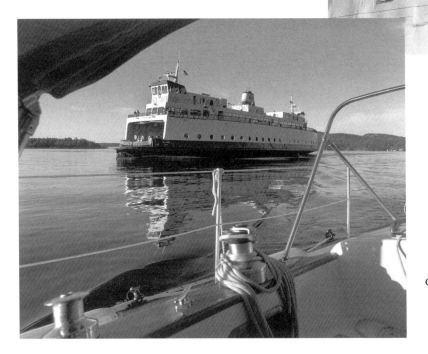

Illahee's round portholes
shimmering shifting image
chrome winches on Louie's sailboat

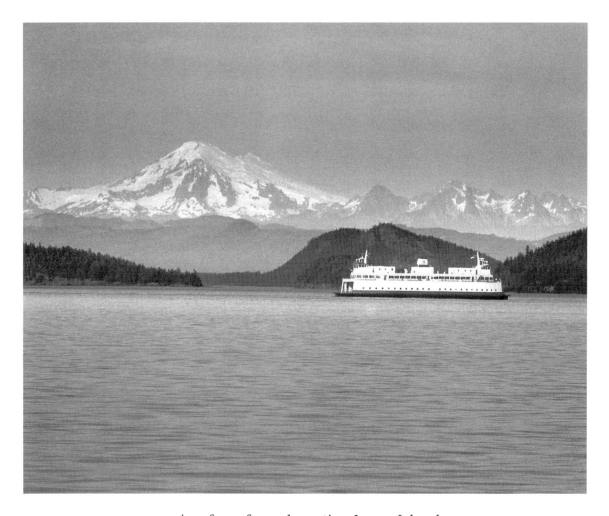

view from ferry departing Lopez Island
Mt. Baker towering above Peavine Pass, Cascade Range in summer splendor
Illahee passing Blakely and Cypress Islands

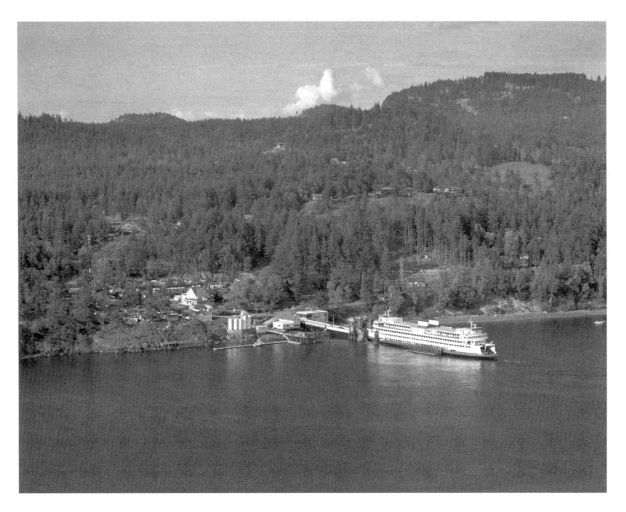

Super Class ferry at Orcas Island terminal
summer visitors heading toward Moran State Park and Mt. Constitution
nine miles from the ferry terminal to Eastsound Village

ferry agent
waiting to lower car ramp
Orcas Island ferry dock

bicycle paradise
San Juan Islands
picturesque back roads

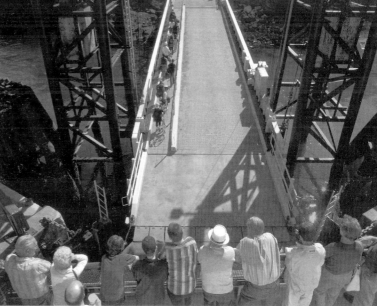

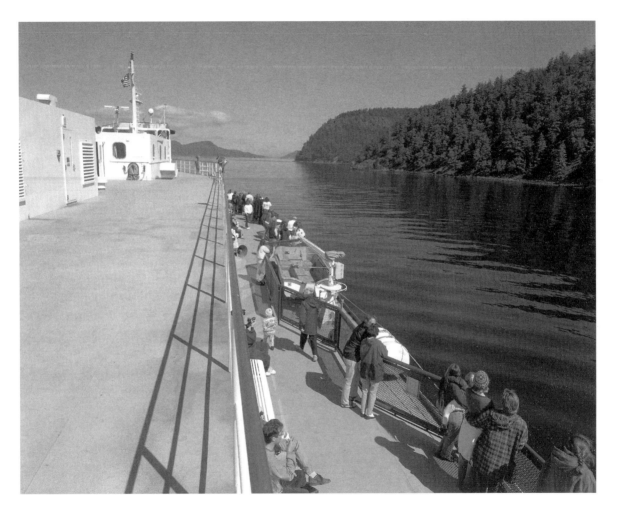

peaceful waters in late spring
Illahee's passengers enjoying warm sunshine and views of emerald isles
long shadows revealing the time of day

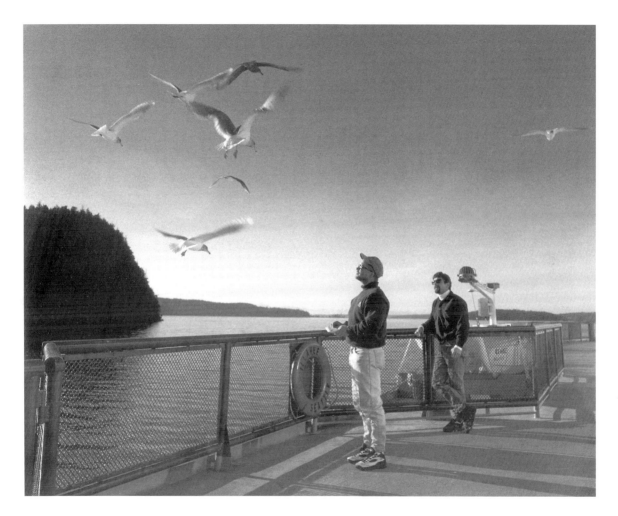

travel companions
mutual observation on *Illahee*'s deck
sea gulls seeking handouts - passengers admiring wonders of flight

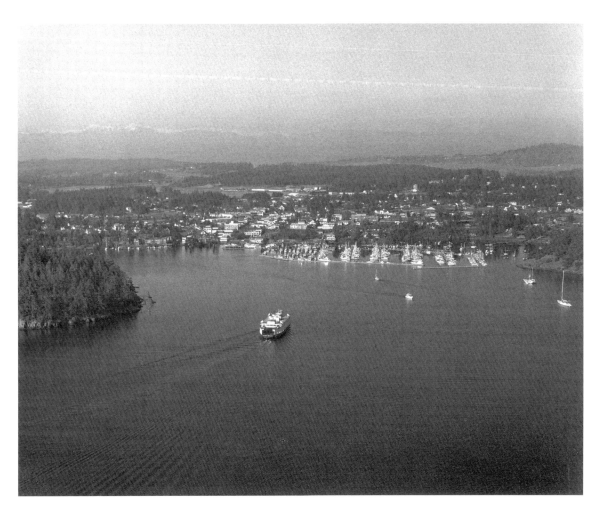

Evergreen State entering the harbor at San Juan Island
marina full with vacationing boaters
distant haze veiling Olympic Mountains across the Straits of Juan de Fuca

Captain Ken Burtness
Elwha approaching Friday Harbor
pilothouse six stories high

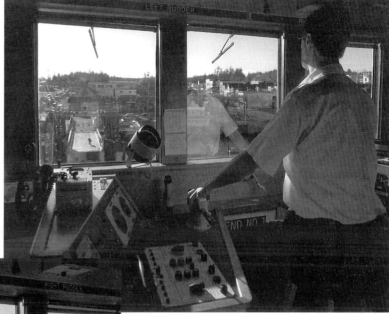

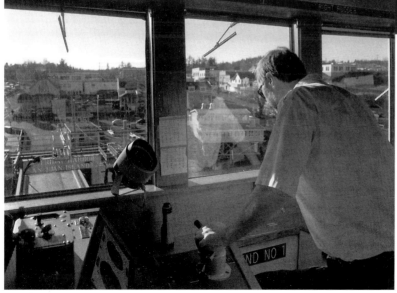

closer now
eyes assessing speed of approach
requiring skill, years of practice

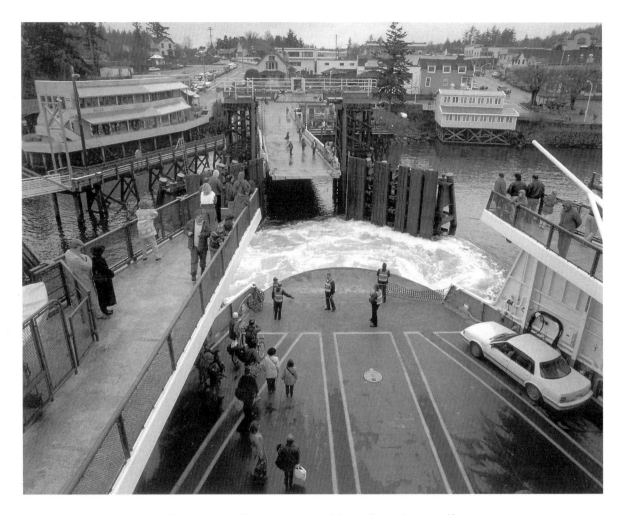

Evergreen State approaching the wing walls
Captain backing down, forward engine kicking up a wake
deck hands and ramp agents prepare for landing at Friday Harbor

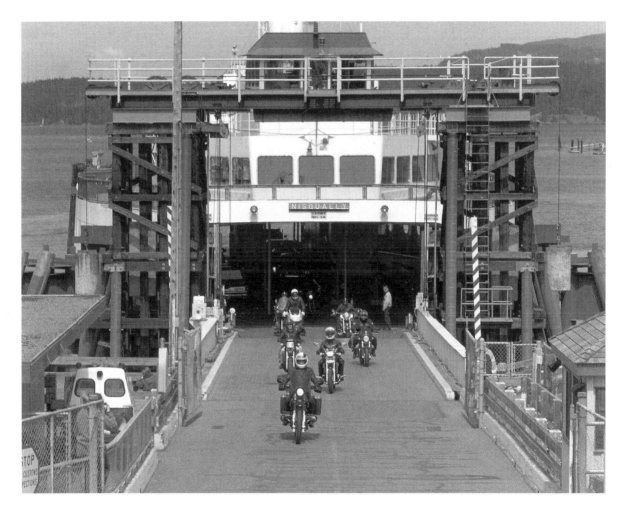

motorcycles
first on - first off
rumble, roar, exodus from the *Nisqually*'s car deck

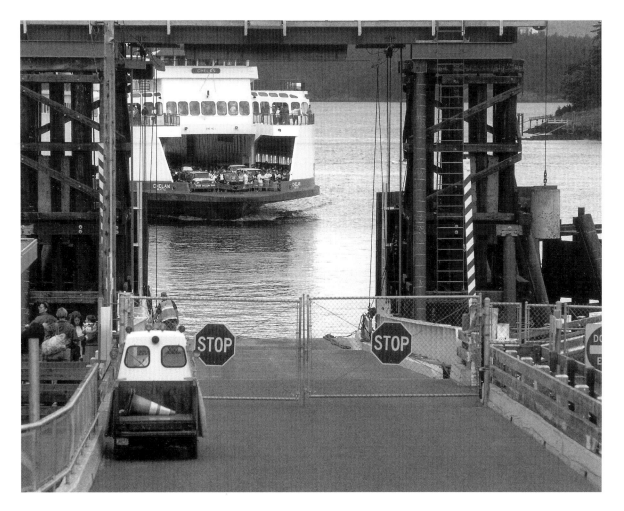

Chelan arriving Friday Harbor
full of joyful anticipation for rousing island event
Jazz Festival!

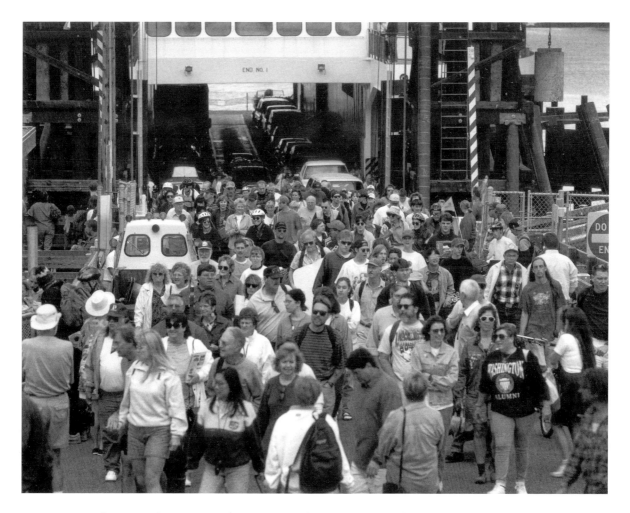

harmonious crowd - sunny afternoon - weekend of fun ahead
walk-on passengers emerging from the *Chelan* at Friday Harbor
Jazz Festival - July, 1995

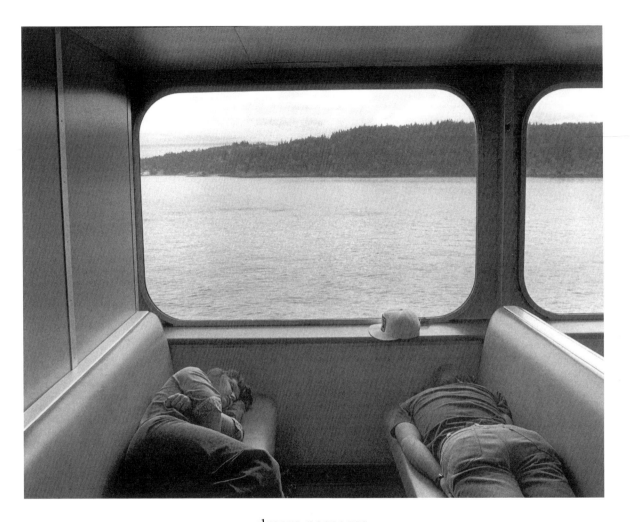

dream passages
"red eye" ferry? commuters? headed home after a fun time in the islands?
probably not first time ferry travelers

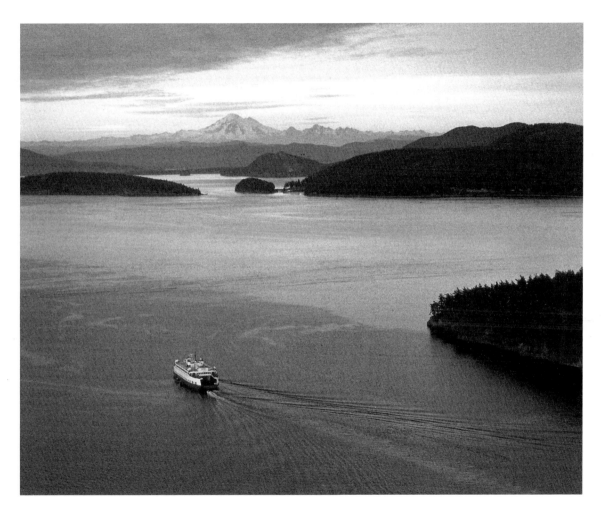

aerial view of the *Evergreen State* rounding Upright Head
sailing toward Peavine Pass - Mt. Baker a distant sentinel of the channel
strong tidal currents challenging navigation

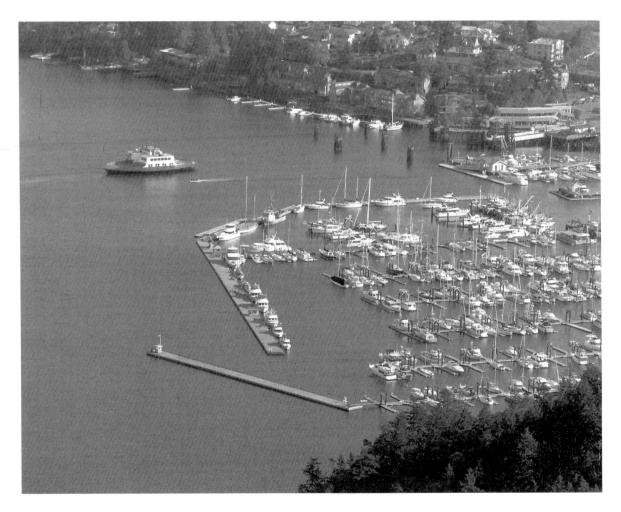

calm after the bustle of day
early summer evening - many guests at the Port of Friday Harbor marina
Hiyu's reflection on placid waters

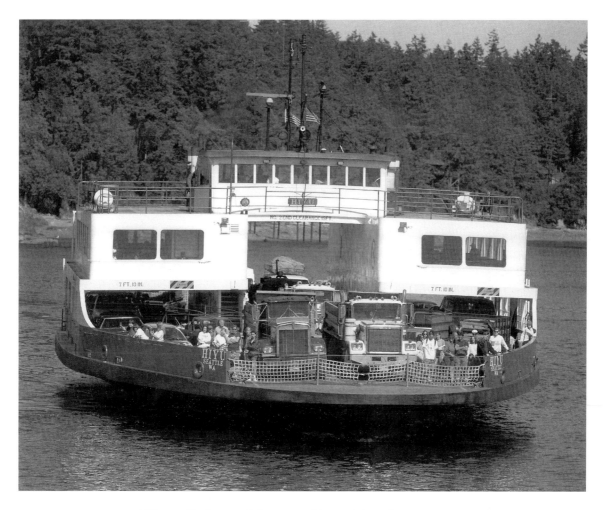

Hiyu - little workhorse of interisland commerce
late afternoon run - delivery trucks, work crews, equipment
returning to San Juan Island

Hiyu
arriving San Juan Island
foot passengers ready to go

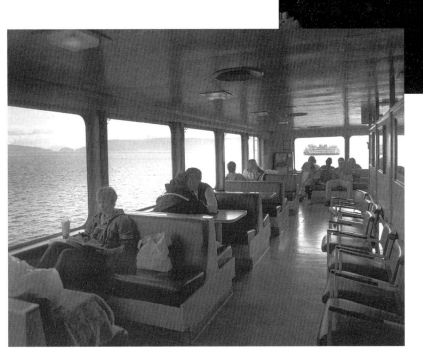

interior of the *Hiyu*
interisland commuter "bus"
larger cousin crossing her bow

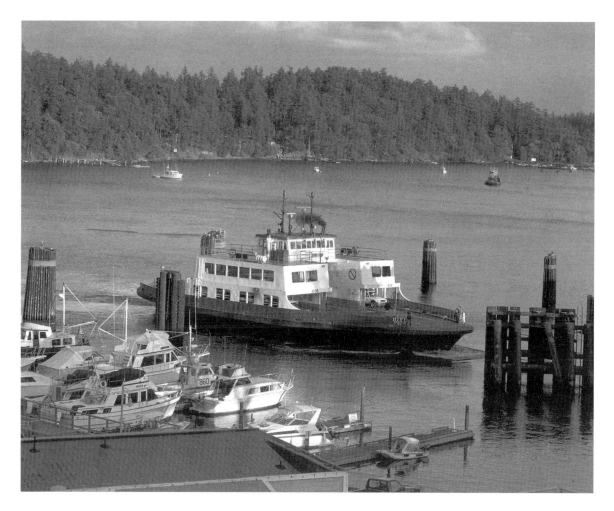

Hiyu putting on the brakes
backing down the propulsion control
arriving Friday Harbor

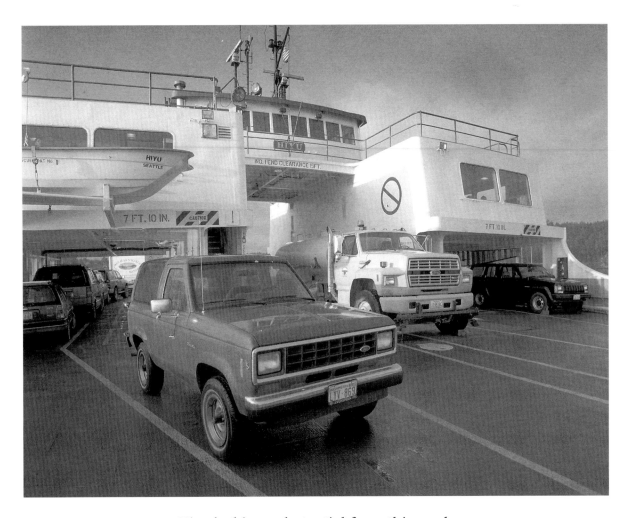

Hiyu looking substantial from this angle

five vehicle lanes - 40 car capacity - tall center lane for trucks

smallest WSF vessel - retired in 1998 - fondly remembered by interisland travelers

Hiyu
studies abandoned
always something to see

Hiyu
spunky interisland transport
"The Little Ferry That Could"

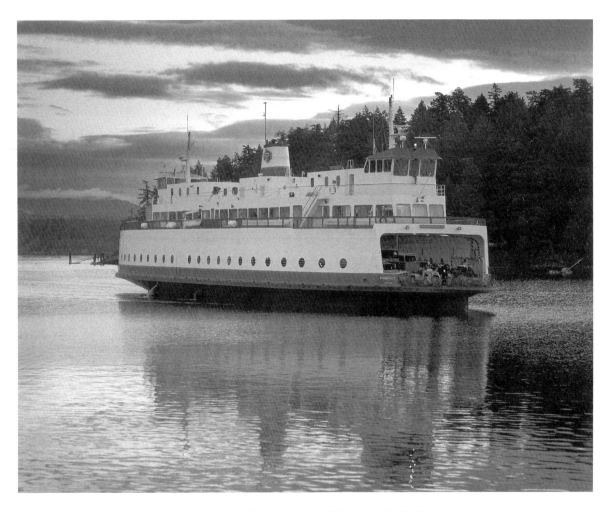

November skies - water like rippled glass
reflections of the *Nisqually*
gliding past Brown Island toward the town of Friday Harbor

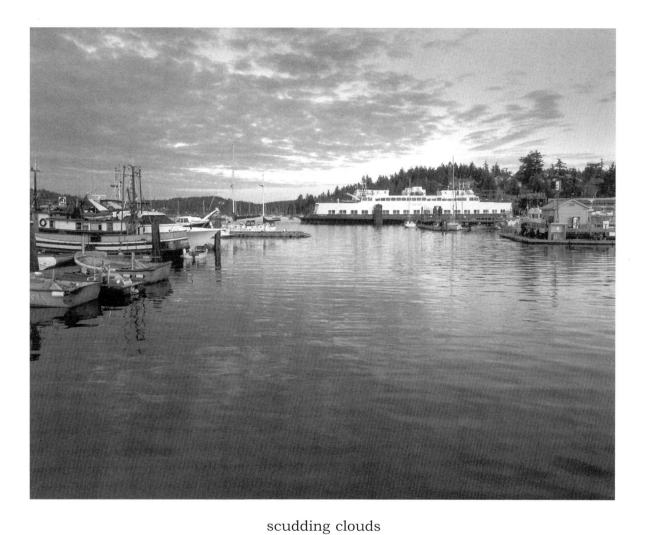

scudding clouds
changing weather - ferries arriving and departing
Evergreen State, a fleeting presence at the Friday Harbor ferry dock

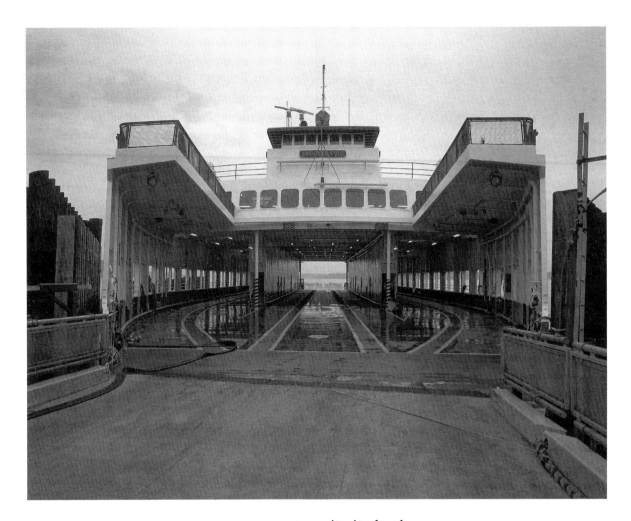

open maw awaits its load
seven vehicle lanes on the *Evergreen State*
total capacity about 100 vehicles, depending on number of trucks and campers

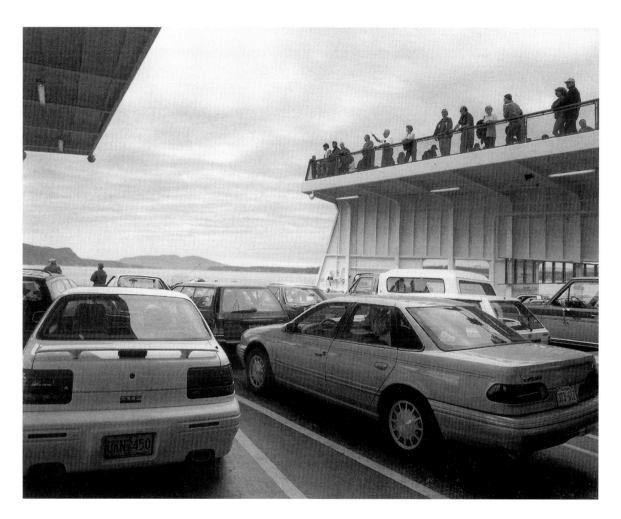

cloudy, but warm in August
Evergreen State cruising open waters
empty cars - ever changing scenic views from the "pickle forks" above

engineer's control station
intercom to *Illahee*'s pilothouse
control backup systems

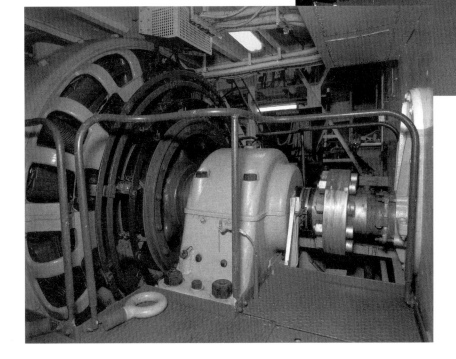

Illahee's electric drive motor
head of propeller shaft
built 1927, still running well

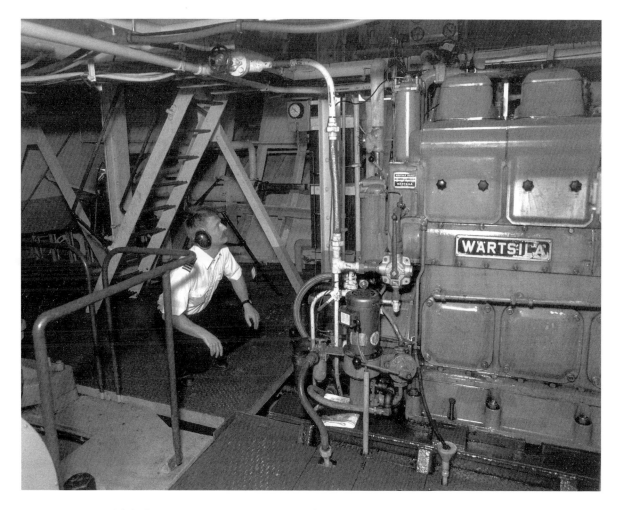

Chief Mate Perry Squires in the engine room of the *Illahee*
Wartsila diesel engine powering the generator
generator powering the electric drive motor

Illahee
sea gulls gliding on the updraft
heading into setting sun

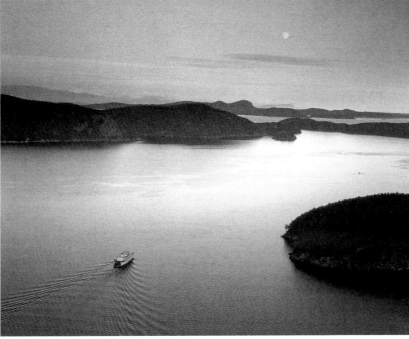

blue moon, June 30, 1996
second full moon in a month
happens once every $2^1/_2$ years

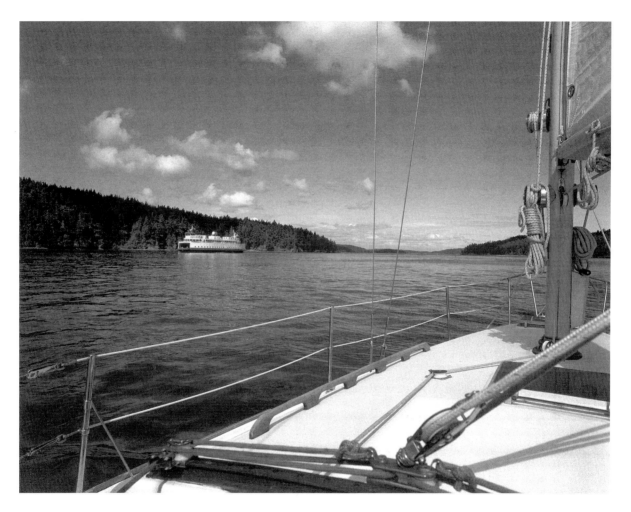

celebrating Independence Day in the San Juan Islands
more than 400 island masses at high tide - weather perfect for sailing and ferrying
exploring sheltered inlets and cruising the open channels

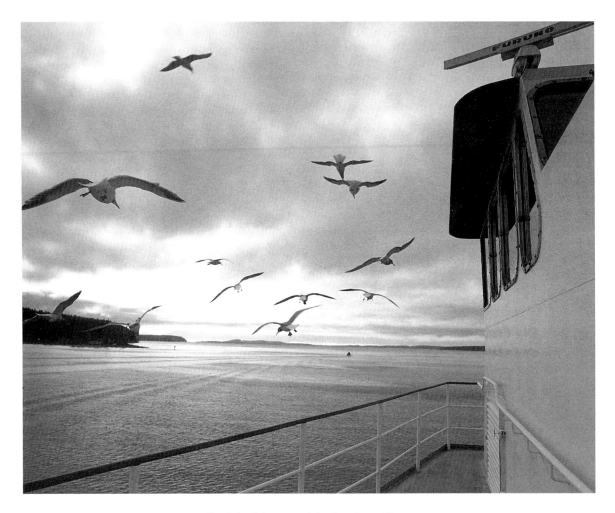

sea gulls hitching a ride in the slip stream
cat's paws on the open sea
Nisqually passing Lopez Island

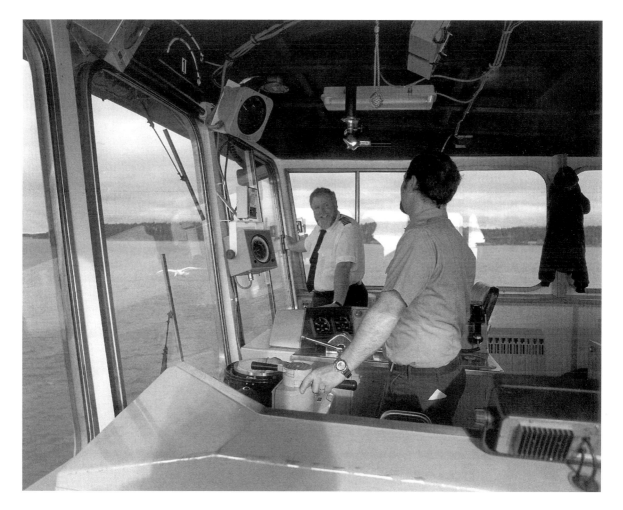

Able Seaman Jim at the helm
obviously a chuckle from Captain Dave Alger
sea gull seems to lead the way

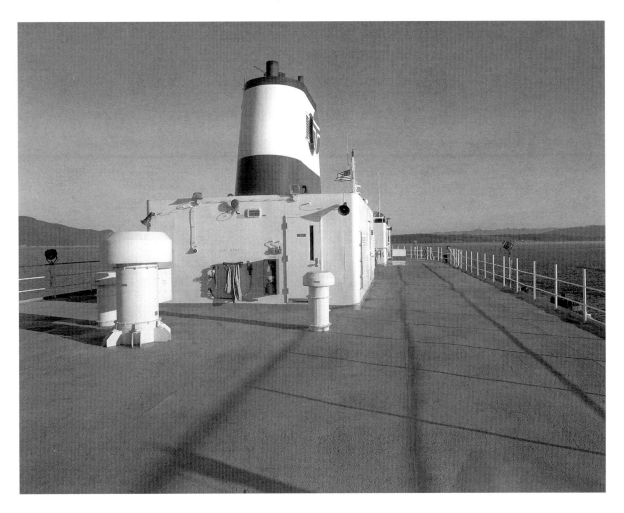

Illahee's top deck
vents - safety equipment - stack
private crew's quarters - pilothouses at either end

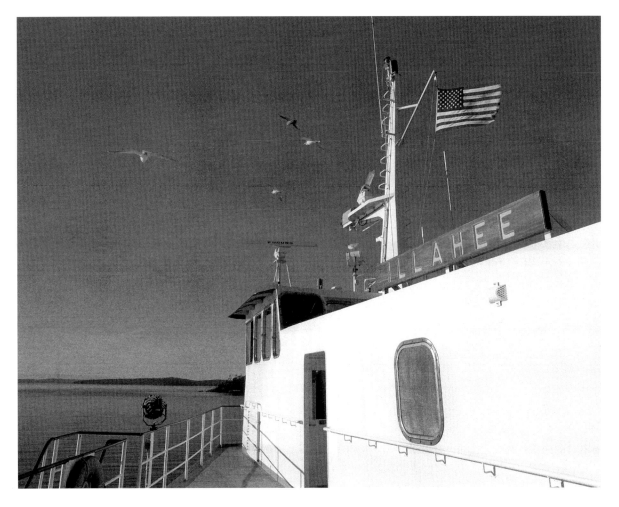

December sunset
Illahee heading westward
into the wind

welcome to Canada - Vancouver Island - Port of Sidney, BC
great place to get married, tour on a cycle, or have a book printed
deck hands ready to secure the dock ropes

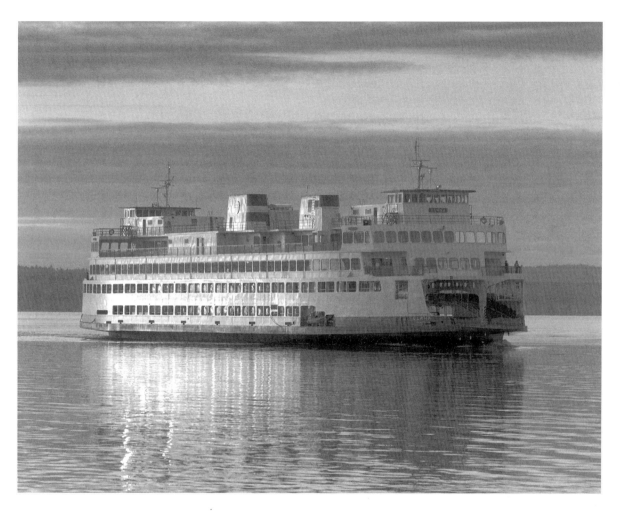

morning light shimmering on the *Elwha*
fully equipped to meet international codes for "safety of life at sea"
daily round trip route between Anacortes, WA and Sidney, BC

Hyak entering the harbor
salt water mirror glass
San Juan Island

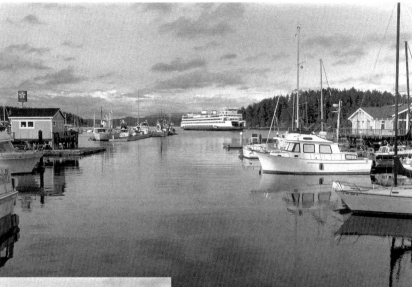

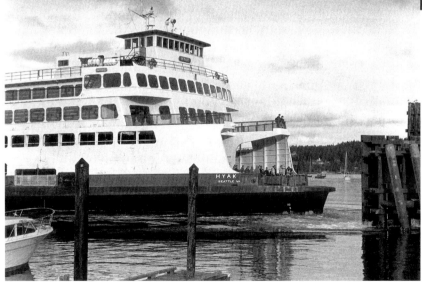

Hyak, Super Class ferry
largest serving SJI route
capacity - 160 vehicles

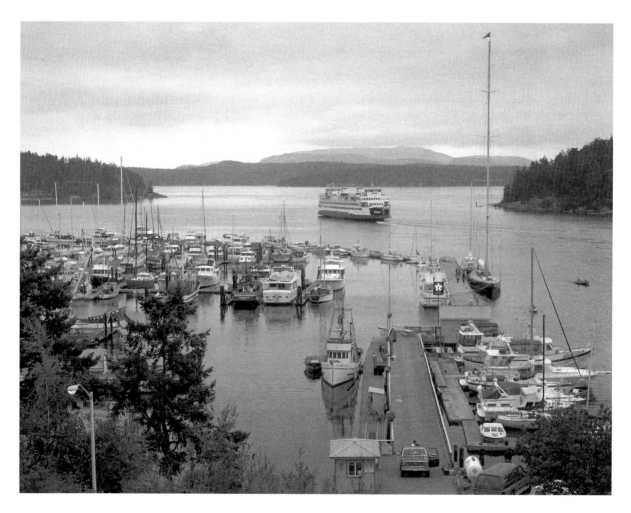

passengers on board the *Elwha* can't miss this unusual sight
165 feet above the water - tallest mast known to visit the Port of Friday Harbor
Endeavour - 130 foot J-Class sloop - charter boat

Hiyu arriving Lopez Island
Captain Ed Gaylord at the helm
through rain or sleet or snow

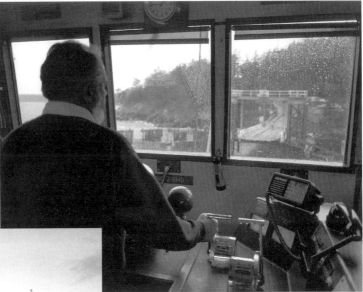

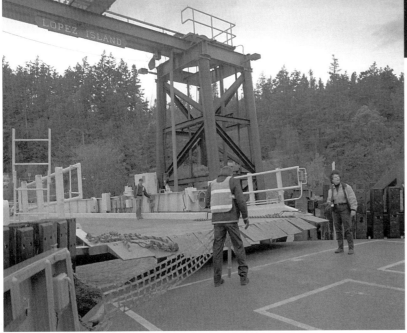

docking the vessel at Lopez
pilot, ramp operator, deck hands
in visual and radio communication

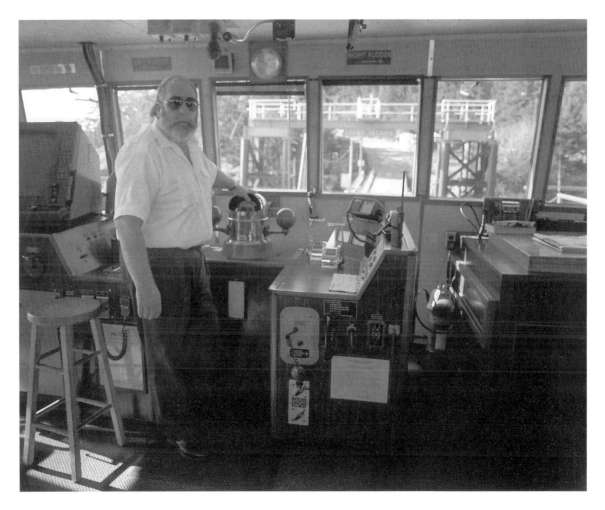

Hiyu secure at Lopez Island
shafts of light spilling across pilothouse instruments
Captain Jack Hamstra at ease

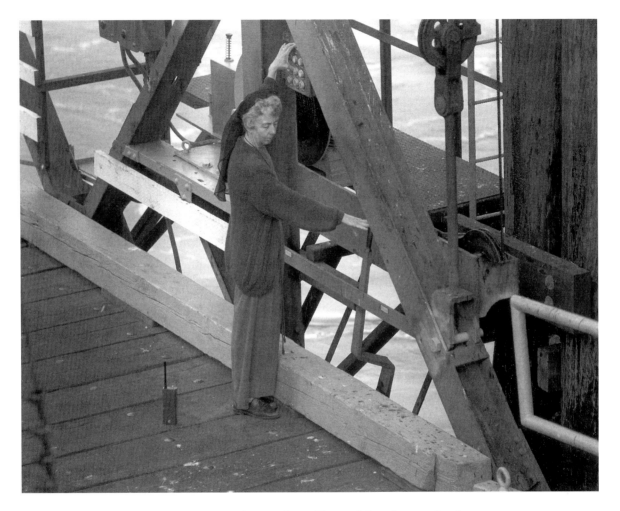

ramp control panel at Shaw Island terminal
Motorola radio communications with ferry skipper and deck hands
ferry agent, Franciscan Nun in brown habit, serene presence

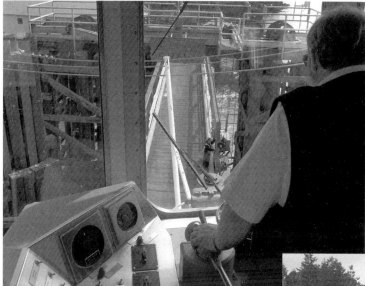

Captain Jack Hamstra
warmhearted, jovial, unflappable
eye contact with nun at ramp controls

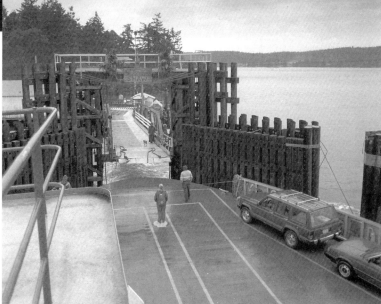

Shaw Island
monastery, chapel, tranquil, rural
smallest of four served by ferries

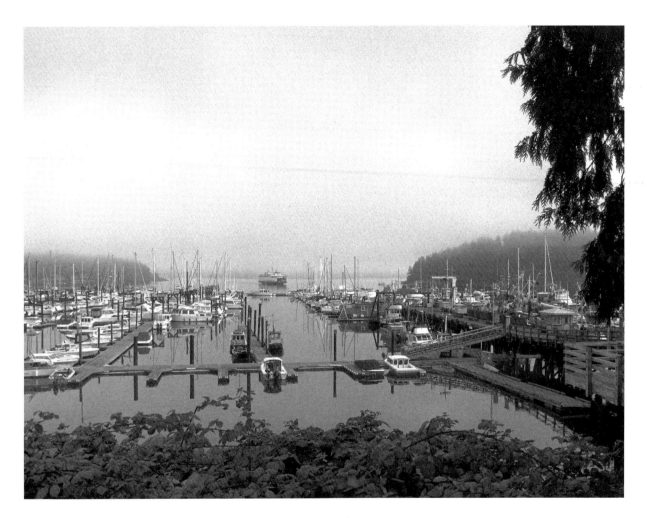

Port of Friday Harbor marina
quiet and peaceful - foggy January morning
Evergreen State approaching - low drone of her engine preceding her form

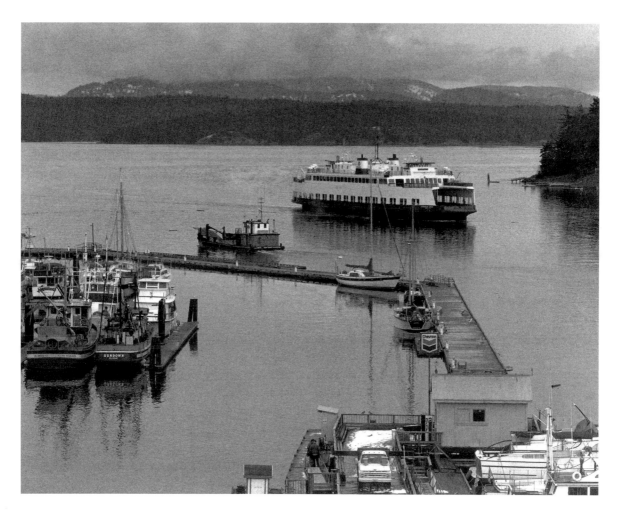

Evergreen State inbound - arriving Friday Harbor
Pintail outbound - work barge delivering fuel and equipment to small islands
homes on about 50 of the San Juan Islands - ferries serving only four

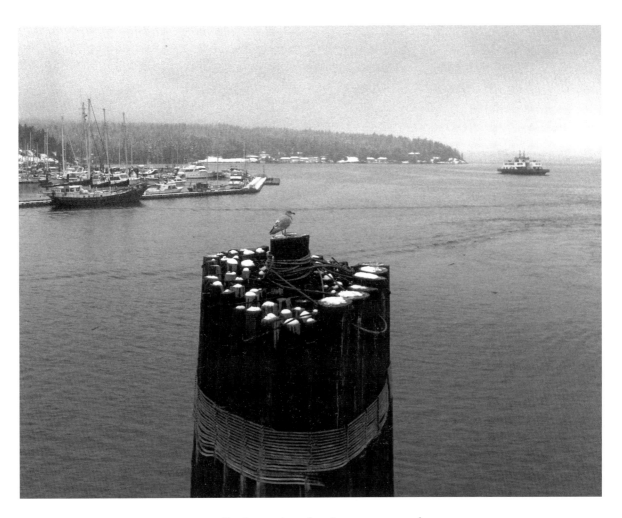

sea gull observing ferries come and go
photographer aboard the ferry to the "Mainland" - departing Friday Harbor
Hiyu, the "Interisland" ferry, in holding pattern, waiting her turn to dock

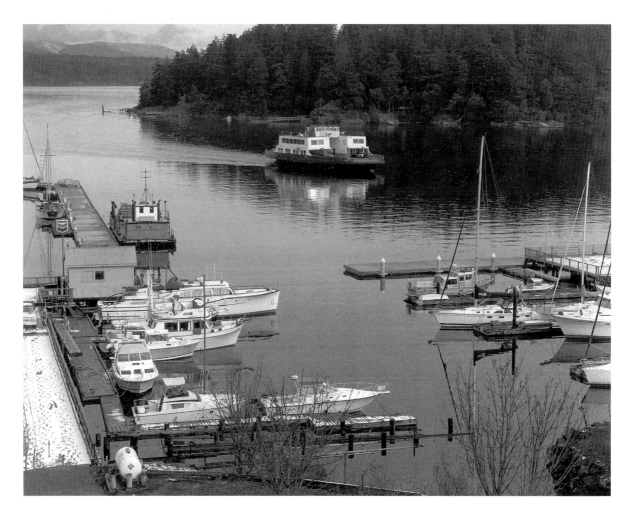

Hiyu, interisland transportation, arriving from Orcas Island
light January snow, traces visible on distant hills
winter reflections at the Port of Friday Harbor marina

unexpected February snow
loading the 8 AM ferry to Anacortes
drivers hoping for traction

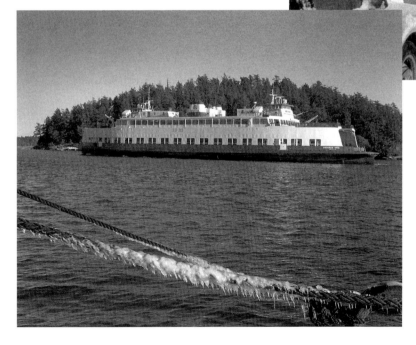

wind, snow, sleet
all-season, all-weather operation
Evergreen State passing Brown Island

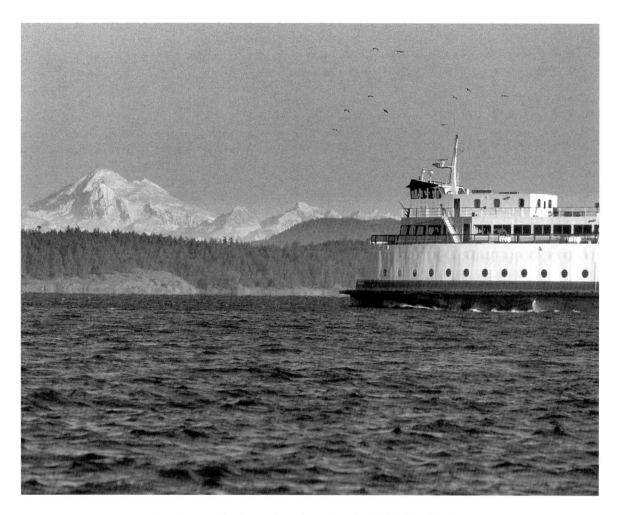

view from the breakwater, Port of Friday Harbor
Mt. Baker glorious in her winter white bonnet of glacial ice
Nisqually with her entourage of flying companions passing Shaw Island

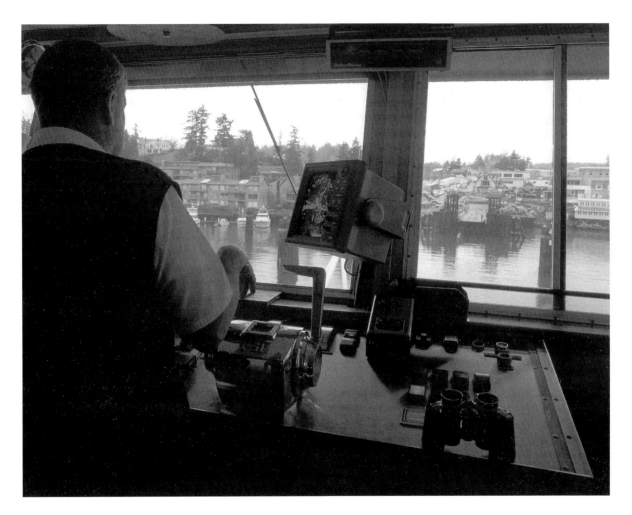

Sealth approaching San Juan Island
radar repeater, addition to fleet safety features in 2001
aide to Captain Fred Engstrom's assessments

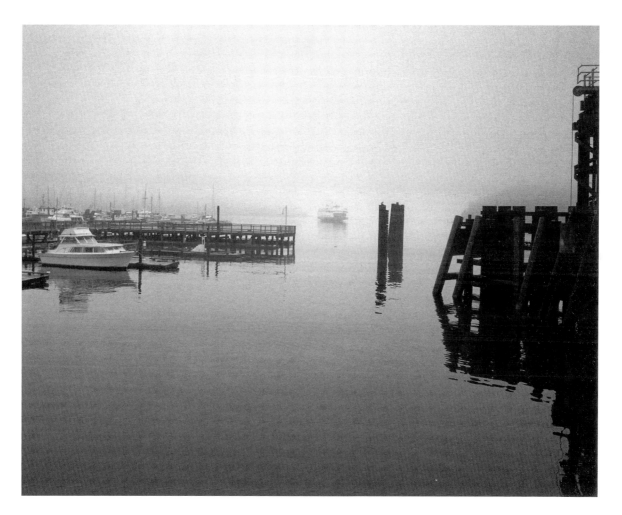

Evergreen State arriving Friday Harbor in dense morning fog
four independent, state-of-the-art radar systems, two on each end
reflective moment of peace on the water

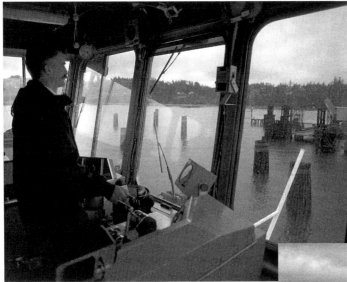

Chief Mate Perry Squires
white "jack staff" - aide to steering
arriving Anacortes

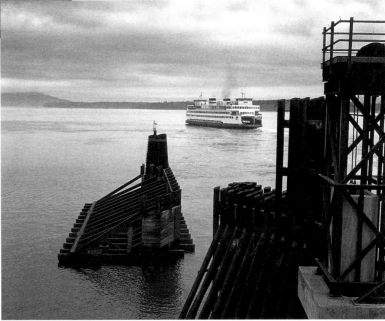

winter chill on the water
hot coffee on board the *Elwha*
departing Anacortes

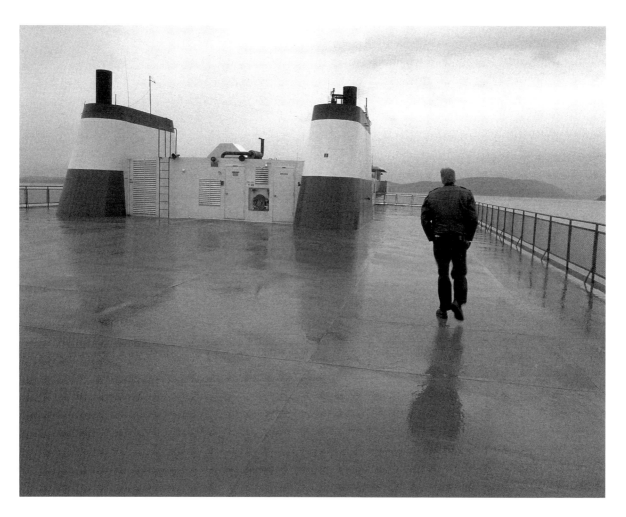

control change passage
ferry boat - two pilothouses, duplicate radar and control systems at each end
Chief Mate Greg Griffith walking to the outbound end of the *Sealth*

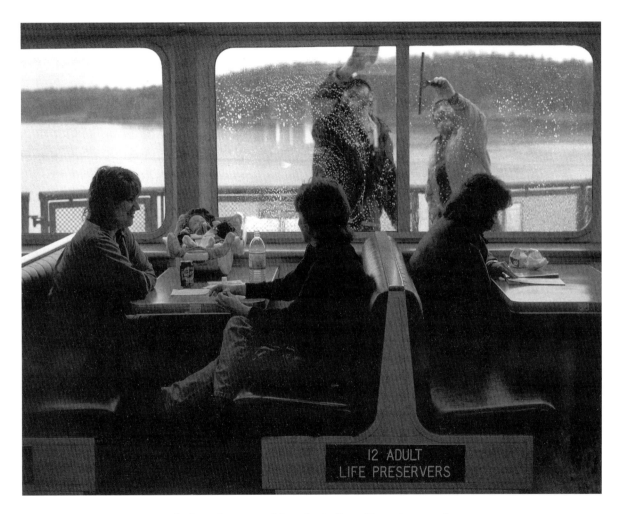

baby sleeps - friends talk - time to read
spring cleaning on the decks
crew members brighten the view

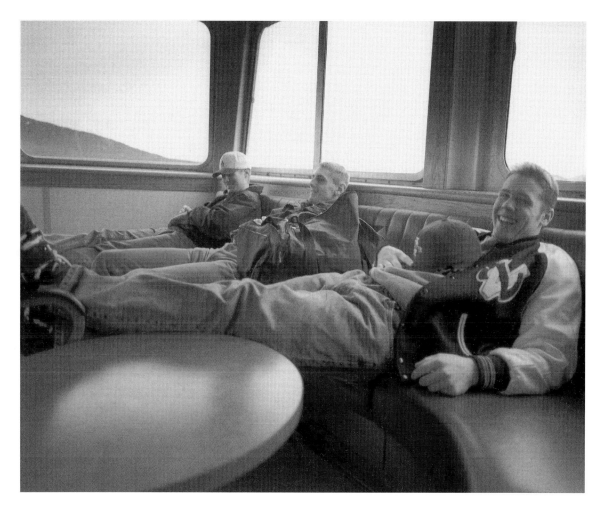

sports dudes
stretched out, relaxing after a game at Friday Harbor High School
returning to the "Mainland" on the *Nisqually*

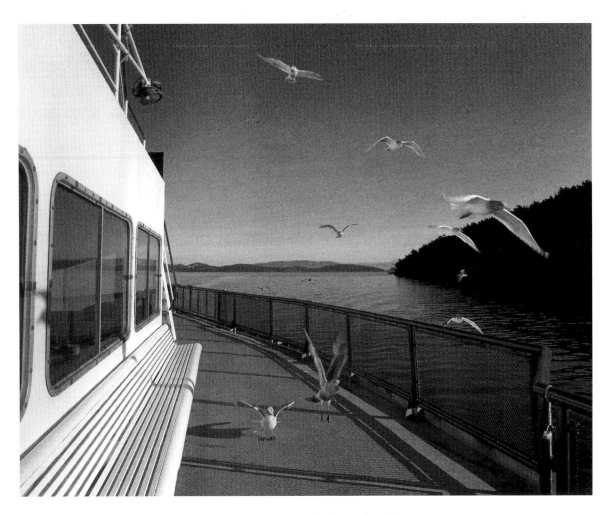

sea gulls flying, gliding, landing
Illahee westward bound toward San Juan Island
crisp December afternoon - sun low - shadows long - passengers inside

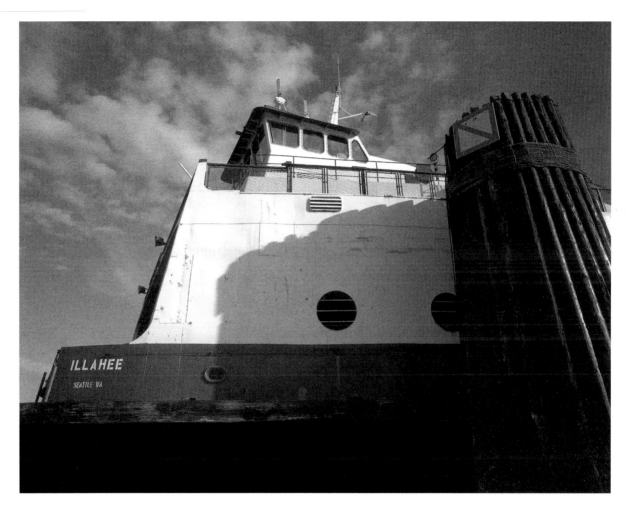

towering
pilothouse - dolphin (piling) - firmament
as seen from small open motor boat

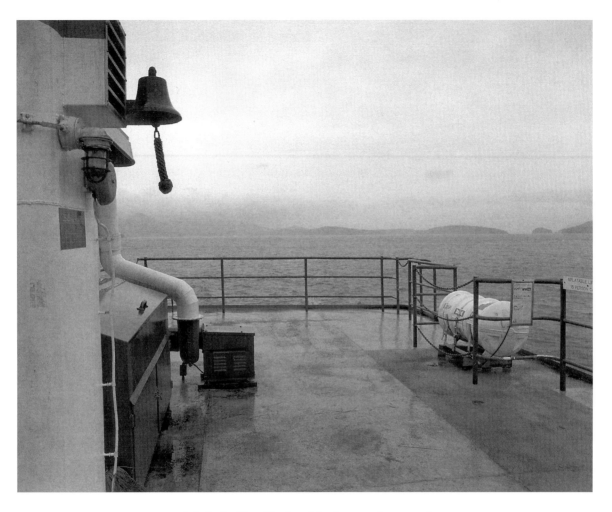

ship's bell with braided rope lanyard
Coast Guard required "sound signaling device"
nostalgia for an era of nautical history long past

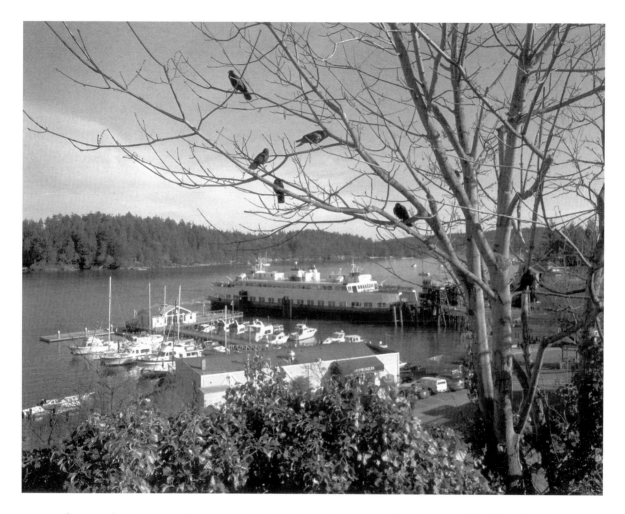

nippy winter morning - sun beginning to warm the town of Friday Harbor
Evergreen State arriving from Anacortes
crows keeping an eye on the photographer for signs of a handout

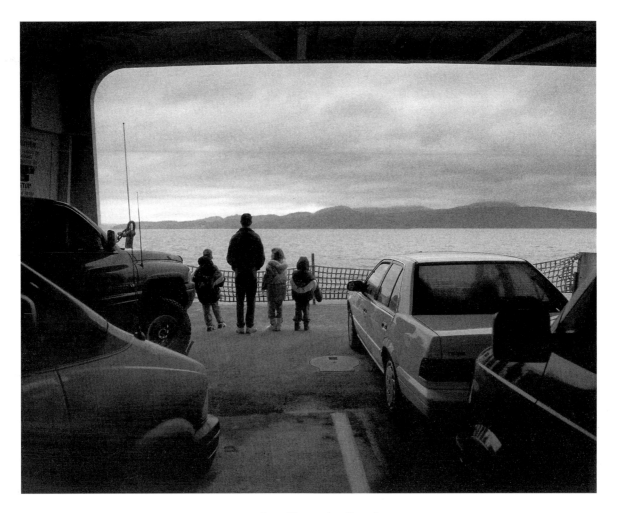

crossing Rosario Straits
father and children contemplating *Illahee*'s progress from the car deck
boots and warm jackets keeping March moisture at bay

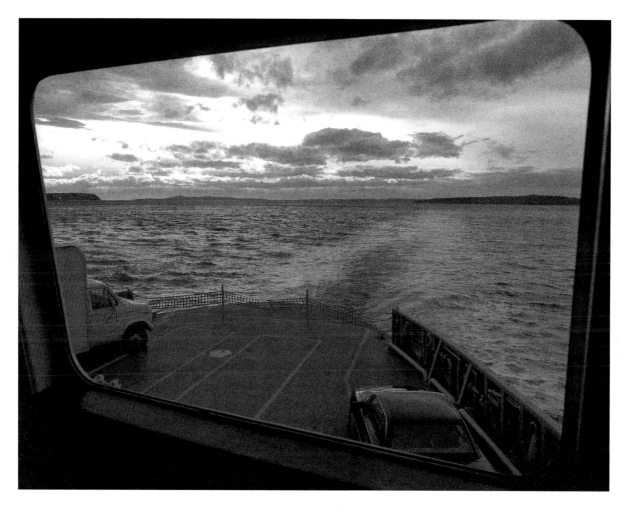

stern wake
luminous twilight accenting watery cat's paws and storm-brewing clouds
Hiyu - one more circuit before her day is done

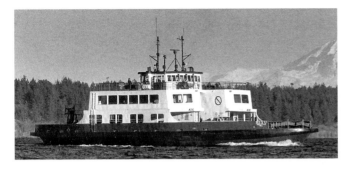

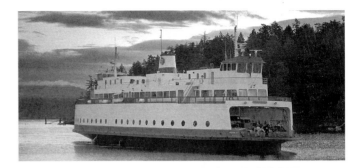

M/V Hiyu

With a slightly ironic name, Chinook jargon for "plenty much," the *Hiyu* is the smallest car carrying ferry in the entire Washington State Ferry fleet. In 1998 WSF retired her from service on the San Juan Islands interisland route. At the time of this writing she is in storage on Bainbridge Island and looking for a new owner.

Built in 1967, the *Hiyu* is 162 feet long, carries 40 vehicles and 200 passengers, and is powered by diesel. For more than a decade, she made the daily rounds between Shaw, Lopez, Orcas, and San Juan Island. Known by many island residents as "The Interisland," she provided transportation to commuters (who live on one island but work or go to school on another), delivery services, visitors, and those needing to come to the County offices located on San Juan Island. Though fondly remembered for her dependability and spunky charm, transport demands outgrew her capacity, and she was replaced by the larger *Illahee* in 1998, and later by the *Nisqually*.

M/V Nisqually & M/V Illahee

Built in 1927-8, and originally named the *Mendocino* and the *Lake Tahoe* respectively, the *Nisqually* and the *Illahee* were moved from the San Francisco Bay area to Puget Sound in 1940. At that time they received their new names - the name of a NW Native American tribe and Chinook jargon meaning "place or land where I am." As two of the four members of the WSF Steel Electric Class, the *Nisqually* and the *Illahee* are each 256 feet long, carry 75 vehicles and 616 passengers, and are powered by diesel-electric engines. Both ships were rebuilt to increase their size to the present capacity in 1958, and fitted with new propulsion systems in 1986-87. WSF has tentatively slated both ships for retirement in 2006.

Easily identified by their round portholes, the *Nisqually* and the *Illahee* have been used in recent years for both the interisland route and the Anacortes/San Juan Islands run. It is a tribute to their builders that these elders of the fleet still run dependably, despite nearly eight decades of hard, steady use.

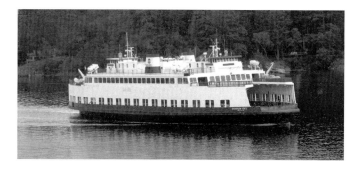

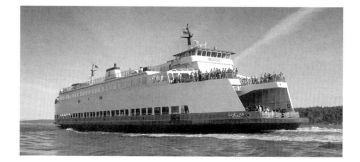

M/V Evergreen State

The *Evergreen State* was the first new ferry built for WSF (Washington State Ferries), which bought the previously privately-owned system and fleet in 1951. One of three vessels in the Evergreen Class, she is 310 feet long and rated to carry 100 vehicles and 1000 passengers. Considered modern at the time, her interior featured air-conditioning, wide bench seats and picture windows. She started on the Seattle-Winslow route in 1954.

In 1988 she was remodeled and fitted to comply with international codes. She even has a duty free shop on board. For the next decade the *Evergreen State* served the Anacortes-Sidney, BC route, with load/unload stops on San Juan Island, and a load stop on Orcas Island. She provided an important link for both island and mainland residents to Vancouver Island, as well as for Canadian visitors to the USA. Commerce and tourism are regulated at both terminals by International Customs personnel. Islanders fondly refer to her as "The International."

M/V Chelan & M/V Sealth

The *Chelan* and the *Sealth* were two of six vessels built for WSF between 1979 and 1982 to meet expanding demand for more ferries and routes. They are members of the Issaquah 100 Class. Each is 328 feet long and rated to carry 100 vehicles and 1200 passengers. The *Sealth* (pronounced See-alth) was named after the great chief of the Duwamish and Suquamish tribes who befriended settlers in the mid 1800s. The city of Seattle is also named after him.

Although they are still in service as of this writing, the Issaquah Class vessels have a somewhat blemished history. Problems included the controversial award of the building contract to a little-known firm, cost overruns, concern for proper testing of seam welds during building, and continued problems with computerized control systems. Because of these difficulties and resulting lawsuits, public opinion of WSF was low during the 1980s. After correcting the flaws and rebuilding some of the vessels in 1989, WSF regained the trust of its passengers.

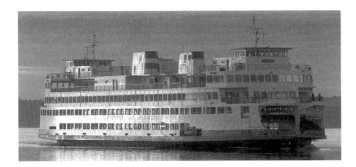

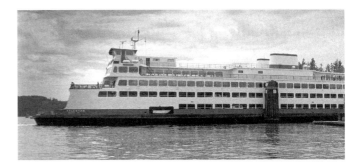

M/V Elwha

Designed by the same Seattle firm which designed the *Evergreen State*, but built in a San Diego shipyard, the *Elwha* (Chinook for "elk") was purchased by WSF in 1967. She is one of four Super Class ferries acquired at that time. Her length is 382 feet (longer than a football field); her capacity is 160 vehicles and 2500 passengers. But even more important, her height (as tall as a six story building!) and 16 foot deck clearance allowed modern commercial trucks to travel on ferries for the first time.

Frequently assigned to the Anacortes-San Juan Islands route, the *Elwha* contributes to the opportunity for growth in island communities as commercial vehicles bring building supplies and food, even complete modular homes. Among the handicapped and elderly, the *Elwha* is popular because it's equipped with an elevator between the car deck and both seating levels. Because she is also fitted to comply with all international safety codes, the *Elwha* is often used for the Anacortes-Sidney route.

M/V Hyak & M/V Kaleetan

Like the *Elwha*, the *Hyak* (Chinook jargon for "fast" or "speedy") and the *Kaleetan* (Chinook for "arrow") are members of the Super Class. They are the same size and have the same capacity as the *Elwha*, as well as the same origin. However, they do not travel quite as fast at 17 knots per hour (compared to 20 knots per hour on the *Elwha*) and neither is equipped with an elevator.

Super Class ferries, which have deeper hulls than smaller vessels in the WSF fleet, are prone to hang-ups with rocks, sandbars, and shorelines at low tides. During their three and a half decades of service, there have been a few instances of running aground. Generally the return of a high tide and the help of a tugboat are sufficient to solve the problem.

WSF moves its fleet among the 10 different routes in the Puget Sound area to suit local traffic demands and necessary repair/maintenance schedules. Thus, from time to time, the *Hyak* or the *Kaleetan* service the San Juan Islands.

Index

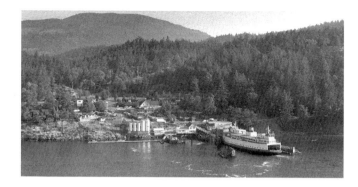

About the Photographer

Robert Demar bought his first 35 mm camera in 1976, and soon began a four year photographic study of the homeless living around 1st Avenue in downtown Seattle, Washington, While on that project, he found himself being drawn to Seattle's waterfront as well, mixing pictures of street people with maritime scenes, including his first ferry boat pictures.

During the 1980s, Robert made many trips to the San Juan Islands with his friends. His interest in documenting ferry travel continued to grow as he photographed the boats, scenery, passengers and crews during these trips.

In 1989 he finally moved to San Juan Island. By this time Robert was using a Pentax medium format camera, working exclusively in black & white film, and doing all of his own darkroom work. Soon he began an intensive study of ferry travel in the San Juan Islands, which now includes around 4,000 exposures, and is still an active fascination.

About his vision for this project, Robert says, "I have endeavored to capture the spirit of ferry travel in the San Juan Islands at the turn of the century. It has been my dream for many years to share some of my work from this long-term exploration in book form. I hope the pictures we've selected from the many possibilities will give you a pleasant adventure on the nautical highways in this island community."

Robert Demar's photographs have been featured in solo exhibitions in Seattle and the San Juan

Islands. He has participated in group exhibitions in Seattle, Everett, and the San Juan Islands. Photographs by Robert have been published in a documentary book, an art book, several magazines, newspapers, and a show catalog. He has won both grants and awards for his work.

About the Writer

Robin Atkins is a bead artist, writer, and book designer. Since her first self-published book of poetry in 1997, she has written and published, "One Bead at a Time, Exploring Creativity with Bead Embroidery," and coauthored "Beaded Embellishment, Techniques & Designs for Embroidering on Cloth" published by Interweave Press. She has three more books on the "back burner" after "Nautical Highways" is released.

Robert and Robin are married and live in the center of San Juan Island with their cat, Sophie.